Robert Frank

ME AND MY BROTHER

steidl

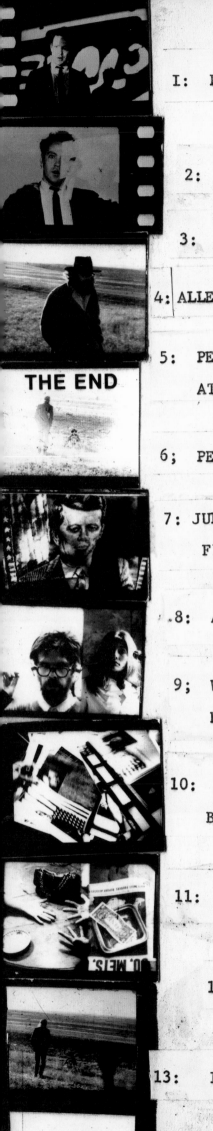

I: PROLOGUE SPOKEN BY THE ACTOR PLAYING PETER ORLOVSKY

2: THE SEX INSTITUTE, A RE-ENACTMENT OF A SCIENTIFIC EXPERIMENT

3: THE SEX EXPERIMENT ON THE SCREEN

4: ALLEN GINSBERG AND PETER ORLOVSKY SING AND READ POETRY IN KANSAS

5: PETER READS DOCTORS REPORT ON HIS BROTHERS CONDITION AS A PATIEN
AT PILGRIMS STATE HOSPITAL

6; PETER'S ACCOUNT OF A DAY WITH JULIUS

7: JULIUS WAITING AT THE DENTIST'S OFFICE. PETER'S RESPONSE TO
FILMAKER'S QUESTION:"WHAT DID YOU FIND OUT FROM HIM?"

.8: A PSYCHIATRIST INTRODUCES HIMSELF.....JULIUS'SESSIONS WITH HIM

9; WHILE VIEWING FOOTAGE FROM THE TRIP TO KANSAS THE DIRECTOR
ENCOURAGES ACTOR TO ASSUME JULIUS' ROLE

10: ACTOR TELLING FILMAKER ABOUT JULIUS AND ALLEN IN CITY LIGHTS
BOOKSTORE

11: THE FICTIONAL GINSBERG APARTMENT

12: THE ACTORS AT THE DENTIST'S OFFICE

13: IN THE DENTIST'S OFFICE A GIRL EXPLAINS HER SELF TO A STRANGER

14: EXCERPTS FROM SENATOR DIRKSEN'S SPEECH

15; A SOCIAL WORKER VISITS JULIUS AT THE GINSBERG APARTMENT

16; AN ACTRESS IS INTERVIEWED

17: SOCIAL WORKER AND JULIUS MEET AGAIN

18: PETER'S RAGE: JULIUS MUST KEEP HIMSELF CLEAN

19: ON THE FOURTH OF JULY THE FILMAKER TALKS TO ALLEN AND PETER ABOUT JULIUS' DISAPPEARANCES

20: PETER AND THE PHOTOGRAPHER IN A POLICE STATION

21: JULIUS HAS DISAPPEARED. ACTOR AND FILMAKER PROJECT HIS WORDS: " I HAVE TAKEN THE LOST EXIT."

22: ACTOR RESUMES JOE CHAIKEN'S ROLE

23: JULIUS HAS BEEN FOUND IN NAPA STATE HOSPITAL. ALLEN READS A REPORT FROM THE HEAD DOCTOR

24: NAPA STATE HOSPITAL RELEASES JULIUS IN THE CARE OF HIS BROTHER

25: JULIUS EXPRESSES HIS FEELINGS TO FILMAKER

Watch out for the cars, Julius. Hey Julius, come on - you want to go or don't you? Come on - I saw you smiling when I told you - come on, Julius - that's not heavy.

The sign says walk - you walk. Walk, Julius - walk. Come on.

Times are changing, you know. Where else, but in 1968, could you get to do something like this? A sex experiment. Not like tearing frogs apart - not like, you know, putting things under slides, looking at them blue and green, but like SEX - right in front of a camera - every second, every minute...where is he?

Hey Julius, come on. We got to get there. They're going to film us making love...I feel horny. I - I feel horny.

Now, the idea is this, and it's a beautiful idea - to record the sex act. It's also a first - it's also a gift to mankind...

IN THIS FILM ALL EVENTS AND PEOPLE ARE REAL.
WHATEVER IS UNREAL IS PURELY MY IMAGINATION

I wouldn't have expected to find this place on this block. They should have a sign out front at least. This is serious stuff. It's not like smokers. It's run by that Doctor...Freud...? Some foreign name like that.

Cameraman:

I don't know...it's always been here.

Actor Peter:

So this is the room...huh? I bet a lot of scenes have gone on in this room.

Cameraman:

Yes, this is it. Just make yourselves comfortable.

Actor Peter:

Julius! Sit down and take your coat off.

Actor Poet:

What sort of people have you filmed here?

John Coe	Peter Orlovsky	Roscoe Lee Browne
Virginia Kiser	Nancy Fish	Cynthia Macadams
Maria Tucci	Seth Allen	Richard Orzell
Fred Aimsworth	Chris Walkin	Otis Young

Actor Poet:

You've been here quite a while, I guess.

Cameraman:

Oh yes, twelve years now.

We get all sorts...prostitutes, female and male homosexuals, heterosexuals...various combinations of each...masturbators, necrophilacs.......Almost every variety of sexual experience known to exist has taken place in this room.

Actor Peter:

Animals?

Cameraman:

Yes, I once filmed two Gibbon apes in the sexual act.

Actor Peter:

I hope you have a lot of film. We might want to take a long time...

Julius! Stick your stomach in! Julius, you better come over here. This is your brother speaking. Julius, they had a couple of monkeys in here and they weren't afraid.

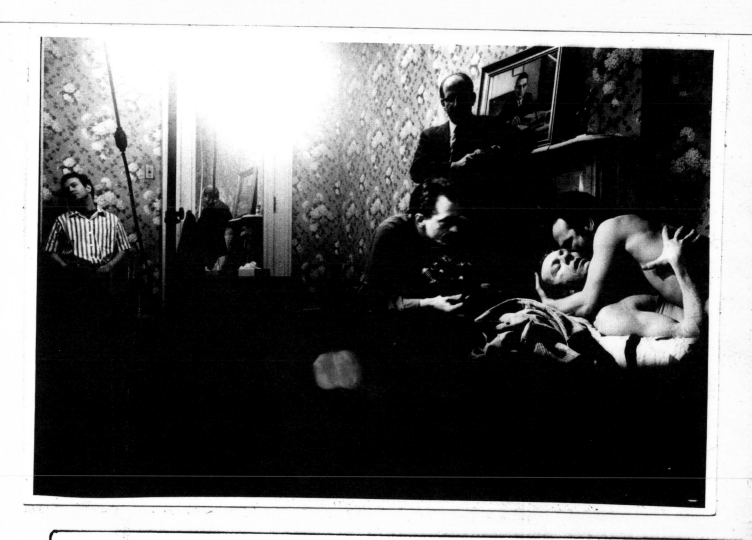

Produced by Helen Silverstein Script by Sam Sheppard and R. Frank

Poetry by Allen Ginsberg and Peter Orlovsky

Editing by Helen Silverstein, Lynn Ratner, Bob Easton

Assistants: Ralph Gibson and Rob Grenell

Distributed by New Yorker Films

Actor Peter:

He's embarrassed.

Cameraman:

Does he watch you when you make love?

Actor Peter:

He sneaks around. We catch him watching and then he pretends he wasn't. Julius, come on over and watch!

Psychiatrist:

I thought you accompanied your brother so much that maybe this time you wouldn't come. For some reason I thought that.

Hey, listen, I'd like to get him in the film, too.

Cameraman:

No problem.

Actor Peter:

Julius, you're going to be sorry if you don't do what the man says.

Actor Poet:

Well, I'll read my poem now. Alright?

Cameraman:

Sure, go ahead.

Actor Poet:

"Rotting Ginsberg"

> "I stared in the mirror naked today
> I noticed the old skull.
> I'm getting balder and balder
> My pate gleams in the kitchen light."

Psychiatrist:

Don't you want to tell me what your feelings are?

Actor Poet:

"...the catacombs, flooded by a guard with
flashlight,
followed by a mob of tourists."

Actor Peter:

This is the movies, Julius. A little movie
never hurt anybody, especially a love scene. How can
you be afraid of a love scene, Julius?

Psychiatrist:

If you care to tell me anything at all about
what you're thinking...I'd be more than happy to help
you.

Actor Poet:

"...a light burst from God;s delicate hand

...sends sown a wooden dove to the calm virgin."

Actor Peter:

He'll get curious and come over here. He always does.

Psychiatrist:

Have you ever seen yourself in a film, Julius? In
a movie? Don't be afraid, Julius. You could even come
back sometime and we'd show you the film if you'd like...
If you'd like that you'd see your brother and his friends on
the screen...then you'd see your face the way I see it
now.....

You'd see your eyes and your nose...

...and your hair

...and your mouth...

Would you like that? Everyone likes that, it's perfectly

normal. Your brother must like it. He's not afraid.

All you have to do is behave; however you behave in

real life. You don't have to act. Julius! There

is nothing immoral about that! I want nothing immoral

from anyone. Julius, I'm perfectly willing to discuss

something with you...

But an effort has to be made on your part! I

can't do it all by myself...

Can you tell me something, Julius? Anything at

all might be of use. Alright then, I'll just pretend

that I know...

Do you want that? Shall I just pretend? Can

you tell me something, Julius? Anything at all.

Anything you want..

3: THE SEX EXPERIMENT ON THE SCREEN

Hey you! See this? See it? That's all I want

to know. That's real! That's imaginary! Yogi!

Casey! That's real!

Woman's Voice:

Julius isn't replaceable...why use an actor?

Man's Voice:

Julius bores me! The whole Orlovsky family

bores me!

Woman's Voice:

I don't understand this scene at all.

Man's Voice:

It looks like he wants a "blow-job."

Woman's Voice:

The best actor in the world wouldn't replace Julius!

Second Man:

This is a wonderful movie. It's great!...I really like it

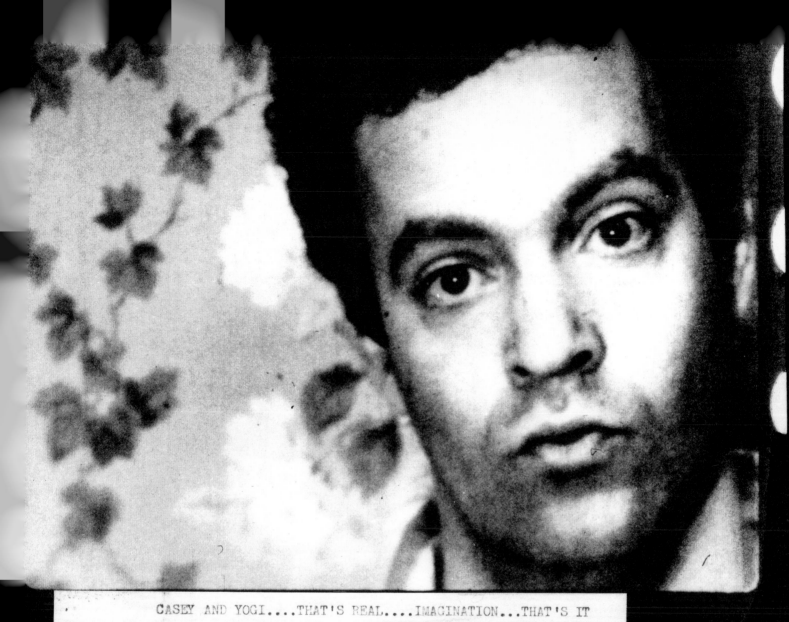

CASEY AND YOGI....THAT'S REAL....IMAGINATION...THAT'S IT

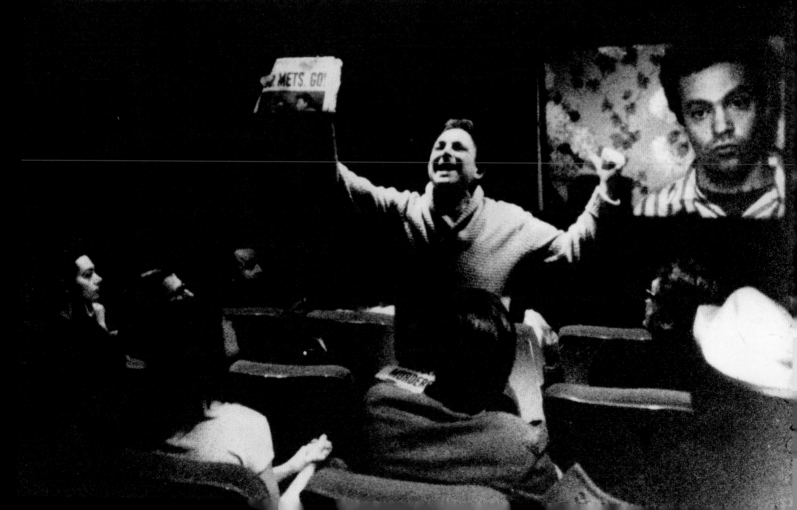

Psychiatrist:

In February of 1966 Allen Ginsberg and Peter
Orlovsky were on a poetry reading tour in Kansas and
they took Julius along...

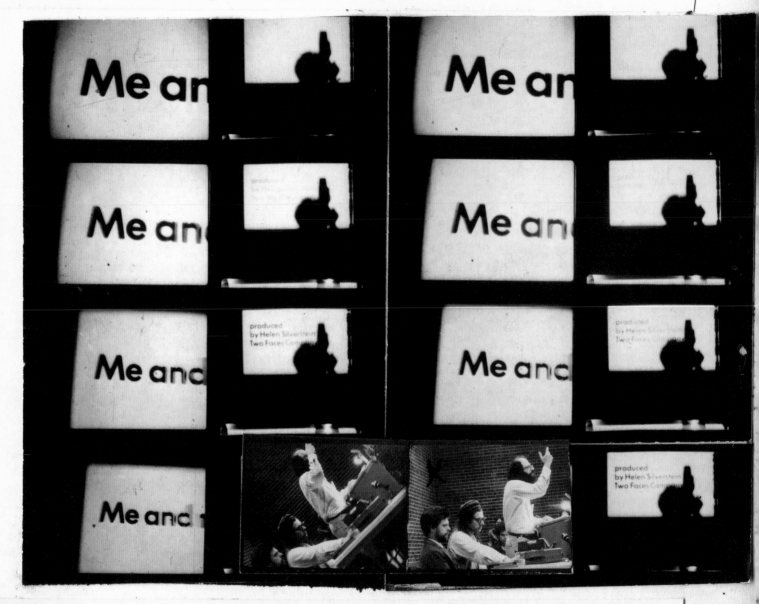

4: ALLEN GINSBERG AND PETER ORLOVSKY SING AND READ POETRY IN KANSAS CITY

Peter:

Okay, all you lovely little loving dolls and mamas
and papas...no, this is not Marijuana, this is just a
plain, old, lovely tobacco.

What?

Voice in Audience:

What do you believe?

Allen:

Actually, what I believe is that the entire
universe does not exist.

Voice in Audience:

Louder!!!

Allen and Peter:

Say something!

Allen:

Say something, Julius!

Julius:

"Say something"

Allen:

Julius says "Say something"

Peter:

Most of you are not aware...you see, all of you, with all your dozens and trillions of eyes and hair links... that my brother has for the last 13 years been in a mental hospital, and I have been trying to get him out for the last 10 years...

The doctors are so stupid and old-fashioned...that ten years ago they said he had to have a nurse for 24 hours... but finally things have changed, and now he's out...and he's sitting before you. His first name is Julius...and he used to be a body builder with a fantastic body.

And Robert Frank who is here , is making a movie of him. And
when Julius looks at a statue or a Picasso ass he takes a loo
whole statue, and that is his little thing.....he is very fur

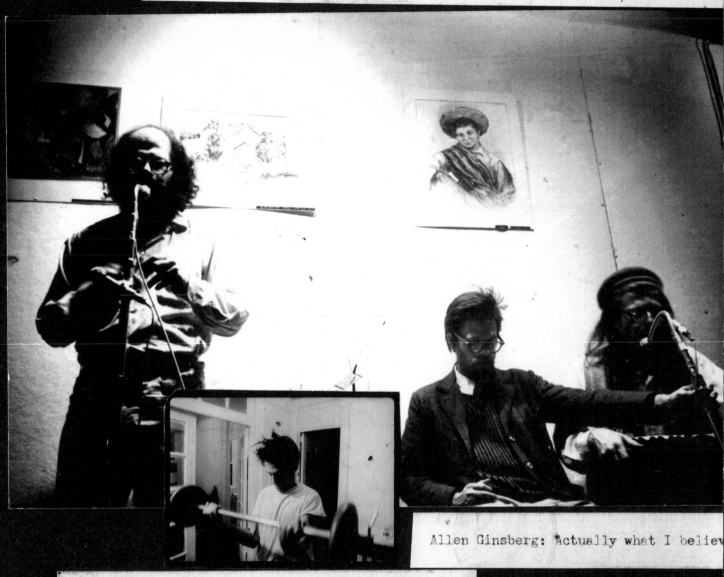

Allen Ginsberg: Actually what I believ

His first name is Julius...and he used to
be a body-builder with a fantastic body...

t says...You know

walks around the

.and very odd....

Peter: It's much worser than pot...
it's worser than marijuana...
because it disinfocals your
eyes and disinfocals your
bowels...see...and so he has
a big bowel hangup

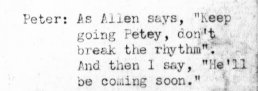

Peter: As Allen says, "Keep
going Petey, don't
break the rhythm".
And then I say, "He'll
be coming soon."

.hat the entire universe doesn't exist

You see...in the mental hospital they gave him
Thorozine...and if anyone here ever had Thorozine...and
I've tried and sampled my brother's Thorozine...it knocks
you out.

It's much worser than pot...it's worser than marijuana---
because it disinfocals your eyes and disinfocals your
bowels...see...and so he has a big bowel hangup.

In Paris I took a lot of heroin...

...heroin is a little white powder that looks like
aspirin mashed up, and it is very simple sometimes to
take...once a month, once every two months...once a lifetime...
you know...once a once.

Everyday I will see him, half blind! With a palsied
hand, dressed in grey state robes, almost morning I meet
him...

He would say: "Come Peter, take me to the subway..."

"...give me a nickel..."

"...come we go to my old barber shop in Brooklyn."

"One day," I said, and led him down the hall...letting
him believe that I was going to take him to Brooklyn.

And there he is, Allen Ginsberg.

Allen:

A giant dormitory...brilliant on the evening plain
drifts with his memories...

Peter:

I don't want all of you to go home tonight and do this!
Do you understand? I'm just trying to help you out.

Allen:

Bombing rains mapped in the distance

Crime prevention shows sponsored by Wrigley Spearmint...

Much delight in weeping...ecstacy in singing...

...laughter rises...that confound idiot staring mayors and

stony politicians eyeing thy breast...

Oh man of America, be born!

Pana para mitra sutra over coffee, vortex, telephone...

radio, bank...aircraft, nightclubs, newspaper, street...

illuminated by bright emptyness.

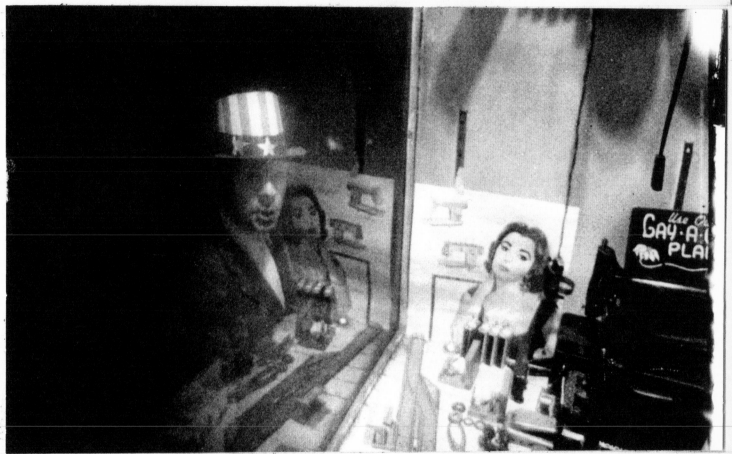

Peter:

As Allen says, "Keep going Petey, don't break the

rhythym." And then I say, "He'll be coming soon."

Allen:

Revolving my head to my breast like my mad mother...

chin abreast at Allah, truth breaks through.

How big is the prick of the President? How big is

Cardinal Vietnam's? How little the Prince of the FBI

unmarried all these years! How big are all the public

figures?

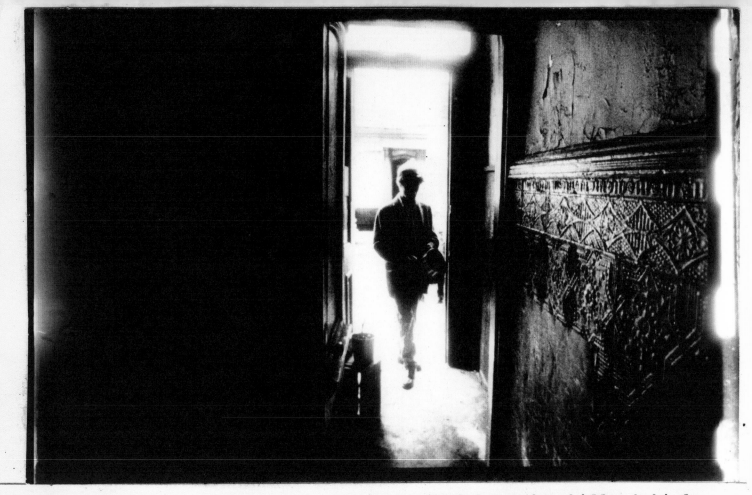

What kind of hanging flesh have they hidden behind their images?

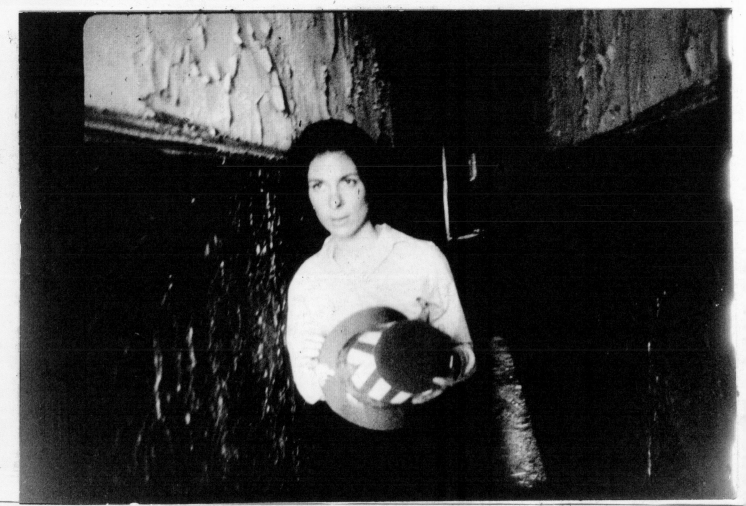

Social Worker:

Julius! Come on, tell me your name. Don't be afraid, Julius. Don't...don't be afraid.

Peter:

Robert, I've got a confra...confrant...confrant...
what the fuck is that word? I, uh, confidential letter from
Julius' clinic. It's a funny letter. I'm going to read
it to you...

"The patient was born December 10th, 1931. He became inter-
ested in art...

"...in 1950 Julius became psychotic while employed by the
sanitation department, city of New York. He was masturbating
while on duty. He became excited...violently resistive, and
was transferred to Kings County Hospital on October 31, 1950.
On November 10, 1950 he was admitted to Saint Marks State
Hospital. He received electric shock treatment.

"Diagnosis was schizophrenic - catatonic type."

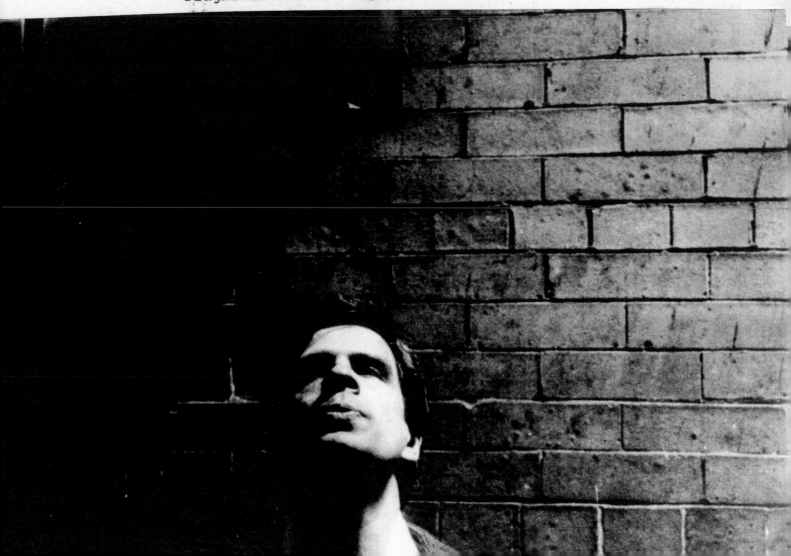

Peter:

"On January 17, 1965 Orlovsky was released from the hospital in care of his brother Peter. Patient has totally regressed, is an almost mute, catatonic man, who works and functions like an automation who never shows any kind of emotional sign. He is completely self-absorbed and harmless.

"He needs the constant close supervision and direction which is provided by his brother Peter.

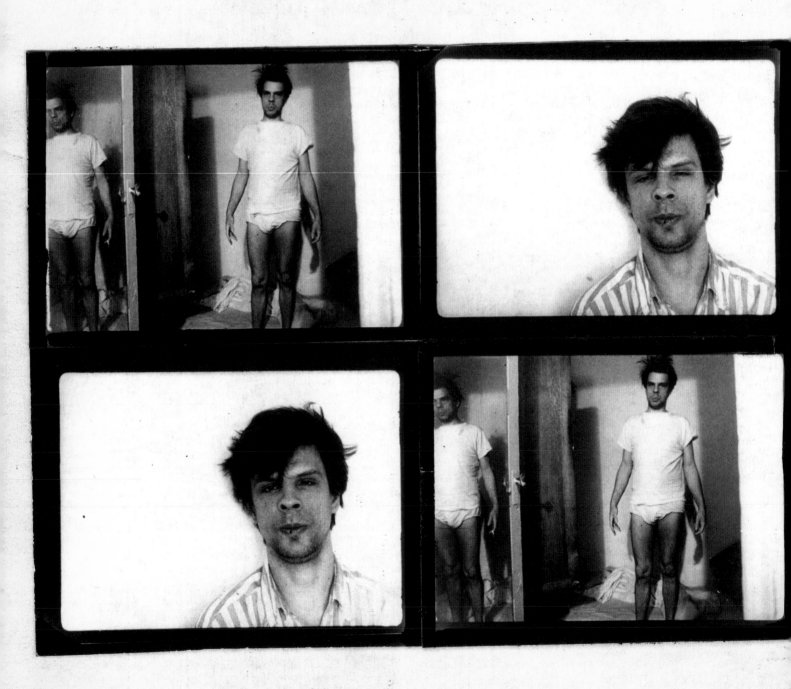

"The patient has been placed on Thorozine, 200 mgs once a day. This different medication was not given to the patient by his brother. Last year he was taken on a tour to the West Coast by his brother, and we lost contact with the patient."

So morning comes and noon comes and I've gotten out of
bed...and I see Julius is still sleeping, so I wake him up...
and tell him to get up. And, uh, he gets up but he doesn't
wash his face...or brush his teeth or go to the bathroom...
or start to make breakfast...he just gets up and stares at
his mattress and wrinkled sheets...

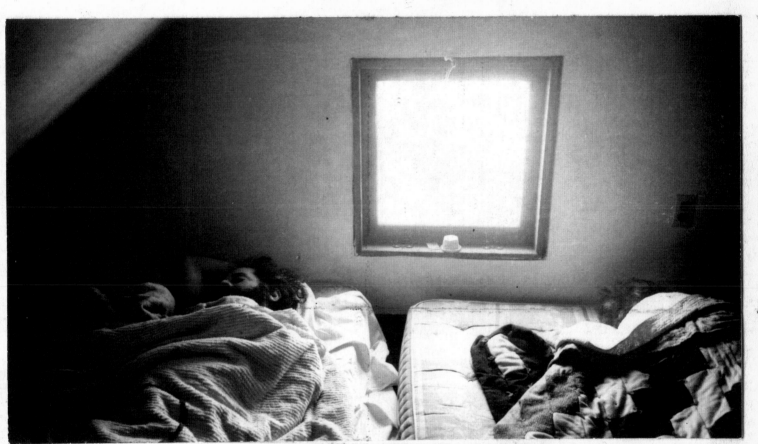

...and, uh, so I've got to tell him to put his clothes
on, so he does that, he doesn't do anything else after that.
So I tell him to wash his face. You know, "...come on,
Julius, let's get going, let's do the things we have to do..."
throughout the day...

And, uh, so he does them one by one, but he has to be told
or else he just stands there by his mattress.

Sometimes I figure...well, let's see what he does.
Maybe he will get up on his own...maybe he'll wash his face
on his own...

But, uh, if I don't say anything, he just sleeps in
bed all day...

And, uh...when Julius goes to bed at night I give him
a kiss...

He looks at me,"goodbye, goodnight"..and sometimes he
gives me a big kiss back and sometimes he gives me a little
kiss...

He never says, "goodnight, Peter," he just says
"goodnight." So I tell him it's not fair. He's got to
say "goodnight Peter"...'cause I say "goodnight Julius."

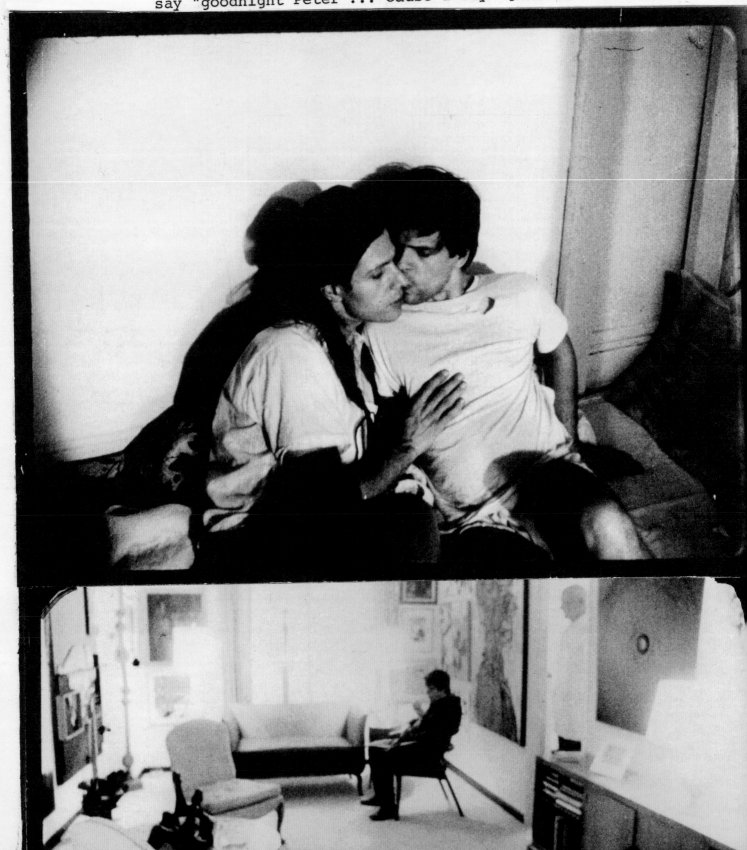

Peter:

What I tried to find out? Why the fuck did he walk
away from me? Why did he get -lost?

Director's Voice:

What did you think when he got lost?

Peter:

I'll never take him on another fucking trip again!
He's unreliable! I'm not going to do anything for him
anymore. I'm not going to sit here and worry about him all
the time. Fuck, no! Goddammit! I'm tired about worrying
about that fucking creep! And I'm tired of hearing from
my father...

"You don't have anything to do...you ought to take
care of your brother."

Screw them all! If that's what they think about me,
let them think anything they want...I'm tired anout worrying
about someone who doesn't want my. help.

Sure. He doesn't even want to mop!

You know why he didn't come back? Because I told him
to clean his room up. And he left the mop in the tub there,
he didn't even clean the tup out, and stuff like that...
that's why he didn't come back, 'cause I told him what to do.

I told him, "...you gotta fix your room, you got to
clean your room up...you got to dust...you got, you got to make
your room look pretty---he doesn't want to do a fucking thing.....

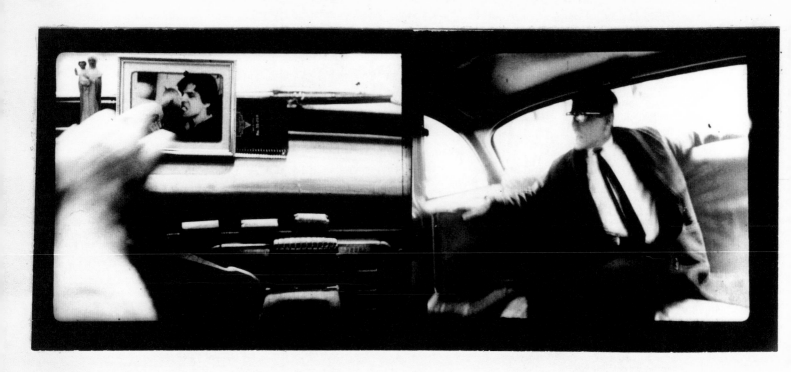

My name is John Coe. I play the psychiatrist and
Julius is one of my patients. I think Julius has a new
vision of today's world. He expresses something we all
feel but we keep it inside us. To me, he is like a saint,
full of poetry, only he doesn't sit in the woods and mountains
of long time ago. It's difficult to be a saint here in
our town. It's difficult to be a saint here in New York.

Many of my patients are afraid to express themselves
just as Julius is, but I feel he expresses more than any
of them, in his way.

Now I would like to begin...

...would you like to begin?

Did your brother bring you to my office?

Are you going to talk to me today?

Can you answer a simple question?

Now I'm going to ask you a simple question.

Does the name John F. Kennedy mean anything to you?

Does the anme John F. Kennedy mean anything to you?

Are you reading David Copperfield?

We want to discover if your trouble is subject to theraputic help, or if you require hospitalization. Where do you live?

Julius:

408 East 10th Street.

Psychiatrist:

Do you live with your brother? What is your brother's name?

Julius:

Peter.

Psychiatrist:

How long have you lived with your brother? How long? Julius, I want to help you express yourself. What is your name?

Julius:

Julius.

Psychiatrist:

What activities please you most? Do you sleep well? Do you still like to lift weights? Do you like to walk around the neighborhood where you live? Do you remember what you were like when you were young? Do you walk by yourself in the neighborhood where you live?

You used to live in Long Island. Do you remember your mother?

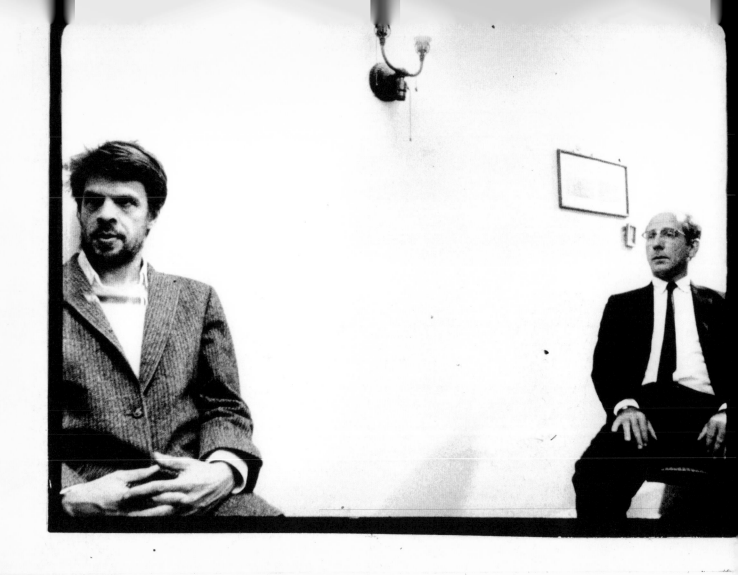

Can you tell me where you go walking?. Did you have
breakfast this morning? Can you tell me what you had for
breakfast this morning?

Julius:

Coffee.

Psychiatrist:

Can you make it yourself? Who made your breakfast this
morning? You ought to take your pills. Two of each,
twice a day...it'll make you feel less depressed. If you
don't take them, does Peter give them to you?

Julius:

Sometimes.

Psychiatrist:

No, you've got to take them every day. You'd be more
relaxed, less afraid. Do some people frighten you?..Do
People sometimes frighten you?...Do people sometimes
frighten you?

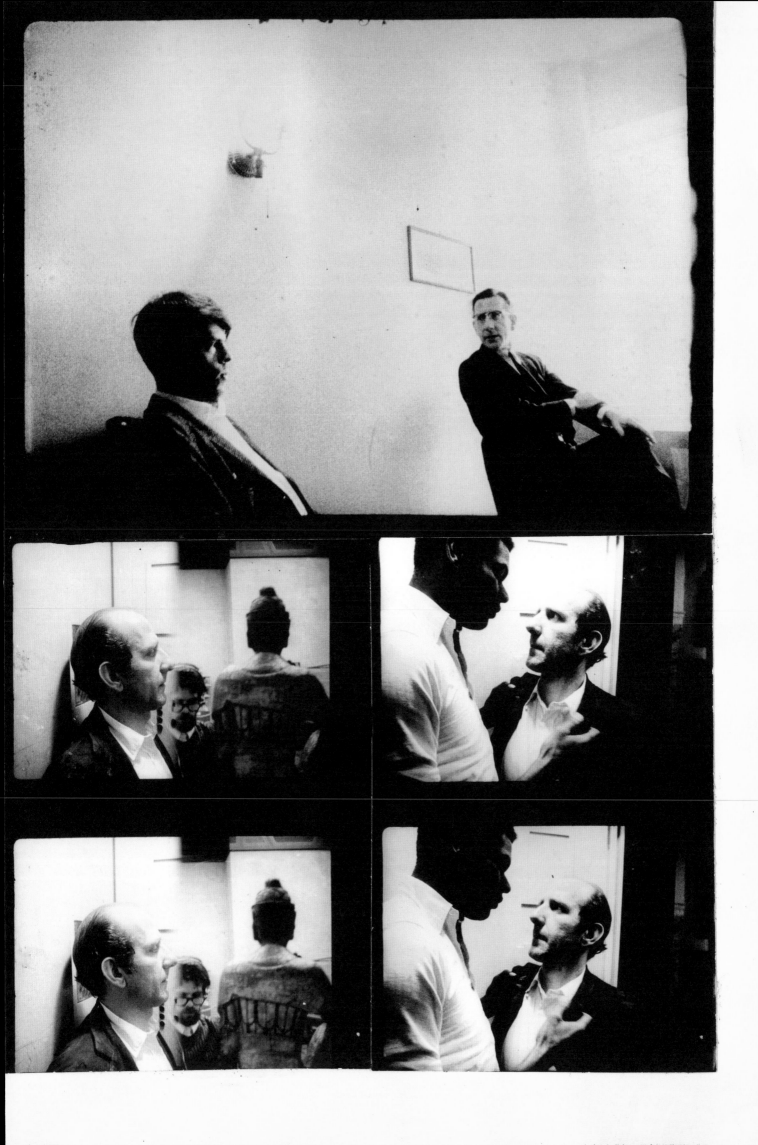

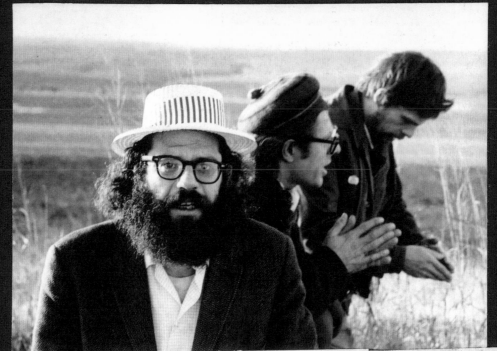

Director:

I can't get Julius to do what I want. I want to use you to replace him.

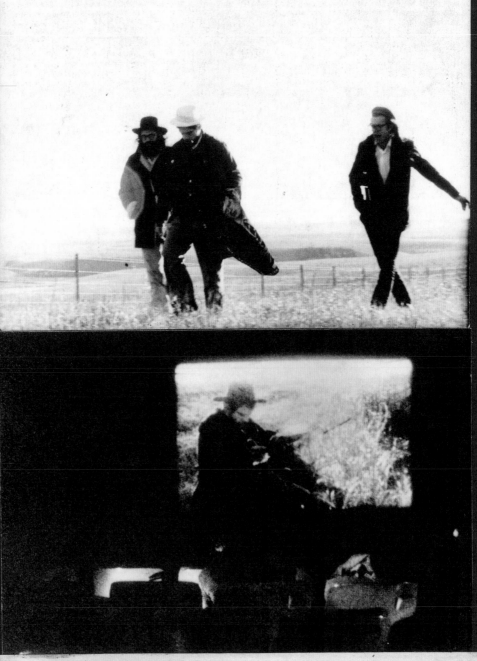

Director:

It's very difficult working with him. So you'll play

Julius, and I'll give you your lines.

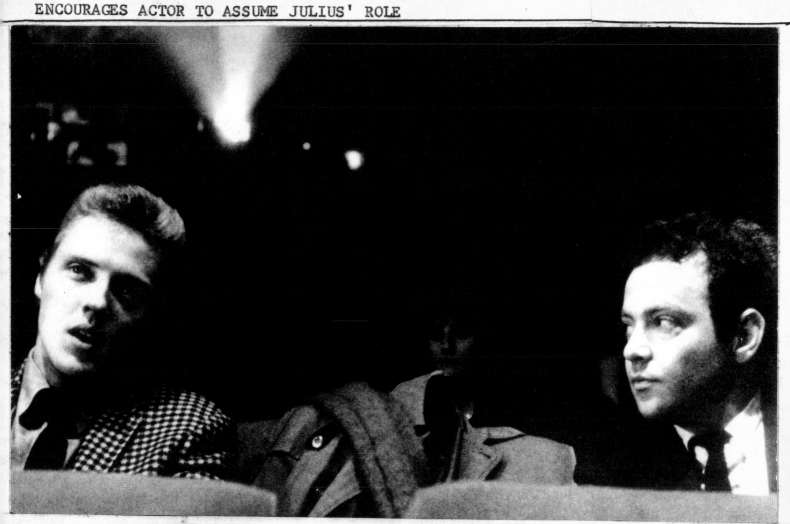

Actor:

　　　Where are they now?

Director:

　　　They're travelling through Kansas. They're coming
from one poetry reading and they're going to another one.

Peter (voice from screen):

　　　Read it again louder. I can't hear you. Read it
again louder. Louder, Julius.

Actor:

　　　Who are they? Brothers?

Director:

　　　Brothers, yes.

Actor:

　　　And you want me to act like them. Act them.

Director:

　　　Him.

Actor:

　　　Does he have a name?

Director:

I told you. Julius.

Actor:

His name is Julius.

Director:

Yes.

Actor:

Why does he shout?

Director:

He can't hear him.

Peter (voice from screen):

Louder. I'm going to throw a pot of cold water on you.

Actor:

How old is he?

Director:

Over 30.

Actor:

White. American.

Director:

Russian. Maybe Jews.

Actor:

Which one?

Director:

Peter and Julius both.

Actor:

Brothers.

Director:

American brothers from Russia.

Actor:

With Allen.

Director:

Allen Ginsberg.

Actor:

Does he say anything?

Director:

Yes. He said, "Something." He said, "Say something."
He has a deep voice, but it's very faint.

Actor:

How do you pick it up?

Director:

A sensitive mike.

Actor:

I could speak loud.

Director:

Just speak the way you are now.

Actor:

Does he like being touched?

Director:

Sometimes.

Actor:

By me.

Director:

By his brother.

Actor:

I won't touch him then.

L

Director:

He wouldn't mind.

Actor:

Do I get to meet him in the film?

Director:

Sometimes. Or else you might disappear. He has,
you know. Now, do you think you can handle that part?

Actor:

Well, I'd like to know some more.

Director:

I think you can do it. I'll give you your lines.

Actor:

Well, what do you want me to do? Look, what does he
think of the room? Of Kansas? Does he hear the words that
they speak? And who's the audience? Where are they from,
for instance? Why can't he get up? Can't he get up?

Director:

Keep on talking!

Actor:

Yeah, but I don't understand what it's about...I don't
know how to go ahead.

Director:

I should be able to see your face. All I can see
is your hands. Move your hands.

Actor:

The lights bother his eyes, I can see that. He
squints at the audience. He could just leave and walk into

Kansas and let the street carry him along. And they could

look at me like I was born there. I could look at them, and...

they could mistake my face for his brother's and run up to

kiss me. I think that that could easily happen in Kansas.

I walk through town looking like everyone's brother and they

don't mind that I'm not. They just let me walk. I keep

on walking. I look straight ahead and lift up my arms.

Director:

I like that siren. Try not to shiver. Just look

straight at me and try not to shiver. You can smoke if you

want. Good. Now, bite the apple.

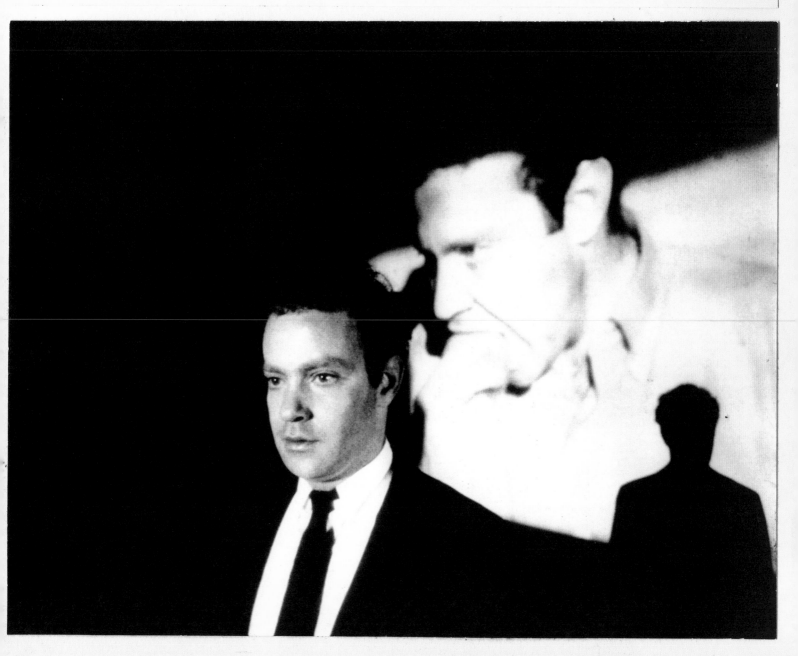

Actor:

Sometimes I get caught sitting for days in one place.
They kick me out into Texas. I go to a room high up in the
middle of a vacant lot. I sit in the window and smoke and
stare at the street. Then I close the window and walk
in circles around a glass bowl with goldfish inside. I
kiss the glass. I lick the fish.

I silently become a friend of myslef. Silently making
up with myself, trying to be friendly with myself and
smoothing myself out. It's sad.

Director:

Pretend that you're Julius now and raise up your arm.

Actor:

Boy, oh boy, it's sad.

Director:

Now look straight at the camera. Straight at the
camera. OK. Good.

Actor:

Things tend to rot. Rotten elements in life. In
other words, I suffocate...I...I suffer...I suffer for what
I do and what I say. I have to take it back, In other
words, not...not to take it back but I have to defend it.
And it's hard to speak always, you know what I mean? I mean,
once your speech is used up, it's used up. You can't teach
any more.

Director:

I've seen enough. Very good. Your voice is good but the mike will pick it all up.

Joe:

You can't take it bakk. You can trade...not to take it back but trade.

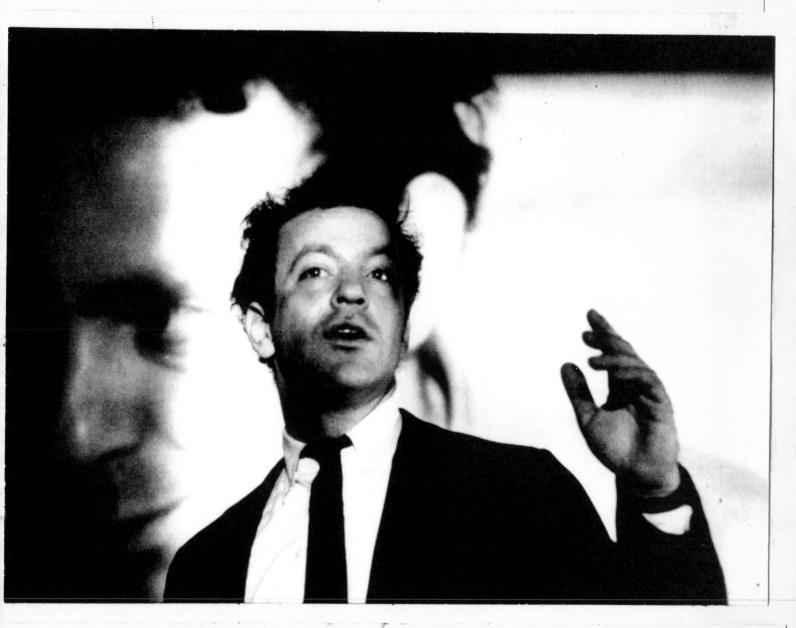

Director:

You'll be alright.

Actor:

Sometimes the trade goes on the blink, you know, it just can't be helped.

Director:

You can act, I can see that. You'll be fine.

Actor:

You have to compromise. That's what Bob Dylan says, "And time will tell, who has been left behind."

Director (off screen):

You'll go through a whole period of being silent. I think you have a good face. You're a good actor, I'm sure of that. I trust you as an actor.

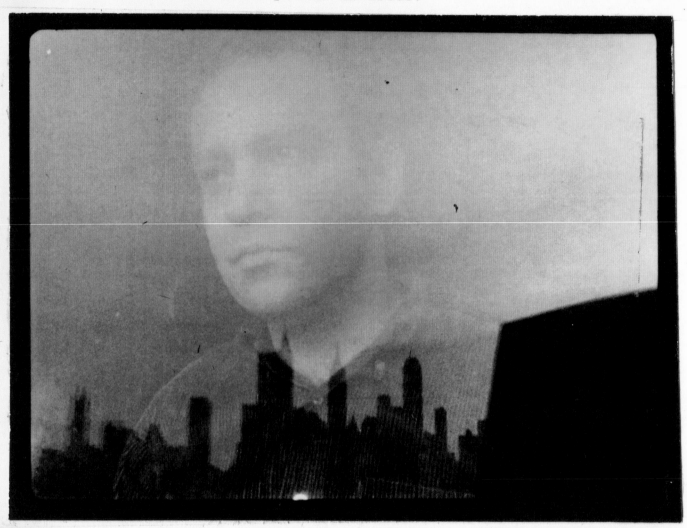

Actor:

I don't trust actors. You never know what they're doing or what they're thinking. They're modifying the way things come out...the way they present themselves to people. But, everybody does that...I mean...everybody sort of edits what comes out. I mean, I'm doing it now.

Director (off screen):

Do you remember when we met Allen and Julius in the bookstore after he came out of the hospital? He was talking, then. Do you remember the situation in the bookstore...the way Allen and Julius talked together, and how happy Julius was? Do you remember what Julius said?

Actor:

Julius was talking to Allen Ginsberg and he said to
him, "What happens to you after you die?" and Allen said,
"Nothing. I think nothing happens to you anymore," and
Julius said, " You mean...you don't see anything...you don't
hear anything...anymore?" And Allen said, "I don't think so"
and Julius said,"Eh, what about-" and Allen said,"I don't
think there's any experience at all after you die," and
Julius said, "You mea-, no soul?" And Allen said, "No, no
soul" and Julius said, "Holy Smoke." Just like that---he

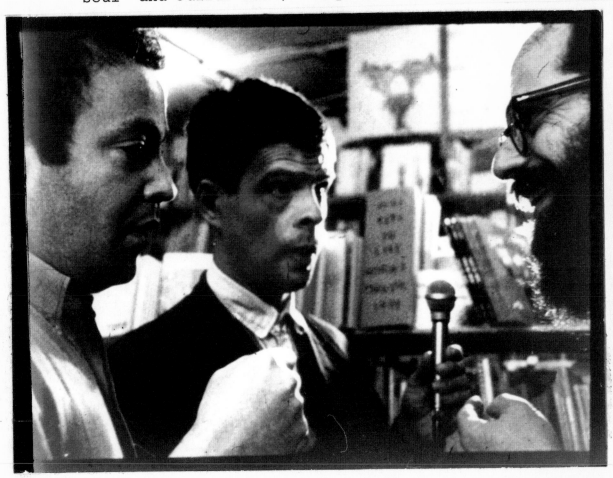

went from soul to no soul---he just sort of had to adapt
to that. Again and again he kept saying,"What happens to
you after you die?" And there was cognisance that he was
not dead...that he was alive, and wanted to know what's
going to happen later. Few times have I ever seen anyone so
alive, so exposed...and he kept talking about good and bad---

were people more bad than good, and that kind of thing really
got Allen excited.....

Allen:

...people are ugly, ugly, I mean both sides are arbitrary conceptions. All conceptions of the existance of the self, as well as all conceptions of the nonexistance of the self as well as all conceptions of the existance of the Supreme Self, as well as the nonexistance of the Supreme Self, are equally arbitrary, being o-ly conceptions. But what do I mean by conceptions?

11: THE FICTIONAL GINSBERG APARTMENT

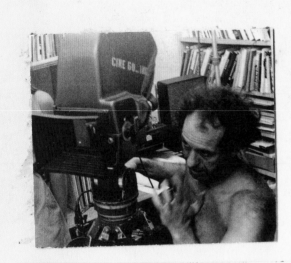

Director (off screen):

OK. Back to the film.

Actor Peter:

Books, books, you got to read books, too

Symmetry, that's what counts. Got to get in shape.

Julius, don't stop, keep it up, good, good, one, two, exercise, exercise, come on, they don't want brains, they want muscles.

Physical fitness, that's good, Julius.

Girl:

Everybody grows up differently. I grew up in New York. New York is really groovy, I love it. I learned how to read in New York and I was 21 in New York. What do you think about the war? Viet Nam? Johnson? Did you go to the Peace Parade? I went to the Peace Parade. Peace is good. Make love not war, right?

Actor:

In Viet Nam...

Girl:

Peace is the groovy thing. I'm for peace.

Actor:

...they're killing

Girl:

...make love not war, right? Wow!

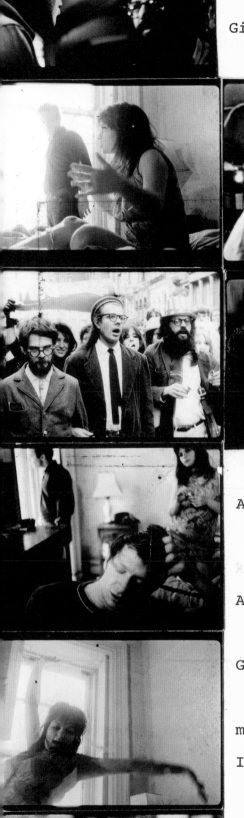

Actor:

...Cardinal Spellman blesses it...

...Peace...you have to march...

Actor Peter:

...dirty, dirty, dirty...got to go to the cleaners...

Girl:

I must be overstimulated. I don't remember if I
made love the next day or not. I'm just a day-dreamer.
I dream in the day and sleep at night. Ah--New York.

What do you think about acting? What do you think
about acting...do you like acting? It's very public, acting

Actor Peter:

Julius, you got to get yourself a job, you got to go
out and work. I'm too busy...I can't be bothered with you
anymore...you got to make some friends...you're not in
shape...you.....

Actor:

And Allen was talking about consciousness, and he
talked about these various kinds of Zen ideas and this
conversation was going on around among all these thousands
of books and titles...and words...and thoughts...and
interpretations...but Julius kept asking the most
primitive kind of questions. He kept asking the kind of
things that most of the people in the books would have been

too embarrassed to ask. It was the kind of thing that
children ask, and you put them off because you don't have
any answers, either. But because you don't have any
answers you don't ask any questions, either. I don't
remember right now too many of the things he asked, oh,
like, eh---

Director (off screen):

Like showing the teeth. Why did you do that?

Actor:

The teeth--well--because first of all I was trying
to understand Julius, and because there were only a few things
that he did that gave me signals of things that were pre-
occupying him and the teeth, the teeth were like a signal...

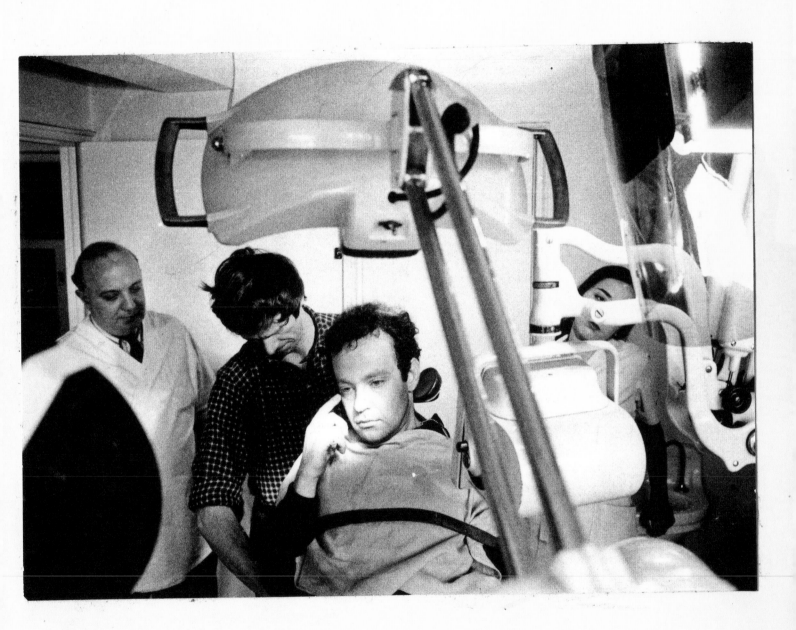

Actor Peter:

Stay in your seat, Julius, and don't talk. Mondrian,

Piet. Soutine. All of those painters. Picasso. Terrific.

Noguchi. Chinese Calligraphy. Matisse does good work too...

Nurse:

Open your mouth, Julius, and pretend you can't talk.

I'll give you a surprise.

Peter:

The agony in the garden--Bellini.

Nurse:

We're going to take a picture of your teeth.

Actor Peter:

Matisse. Indian Pop Art.

Nurse:

Well, it has red and white stripes.

Actor Peter:

Another Matisse...Julius, keep your mouth shut.

Norse:

That's fine, Julius, just hold it open like that and
we'll be all done.

Actor:

How long will it take? How long?

Actor Peter:

Julius, open your mouth and keep still.

Nurse:

Julius, behave. I'll give you a surprise. Good boy.

Actor:

If you have something for me I could have it---I
could have it NOW.

Nurse:

I don't have anything. No. Stay away from me.
Stay away.

Actor Peter:

Leave her alone. You better watch out, Julius -
remember what I told you before.

Dentist:

Der Kerl Ist Unmoglich Zu Behandeln.

Actor Peter:

All right. Let's go home then. I'll just leave
you here, then.

Dentist:

Sie Konnen Ihn Nicht Hier Lassen Ich Muss Die
Bude Schliessen.

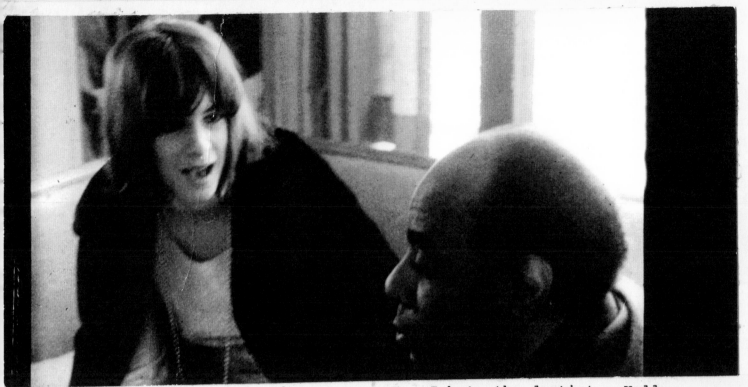

God, I'm so nervous. I hate the dentist...Hello,
Hello. I do know you - I met you once - it's true-
that's why you're smiling. I think I met you downtown.

I don't go downtown every day - I think it must have
been in the Spring or something. I think I met you in
an elevator. Didn't I? You don't remember, huh?

Hey - didn't I meet you in an elevator? I did.
Photographer:

No - I don't ride elevators.

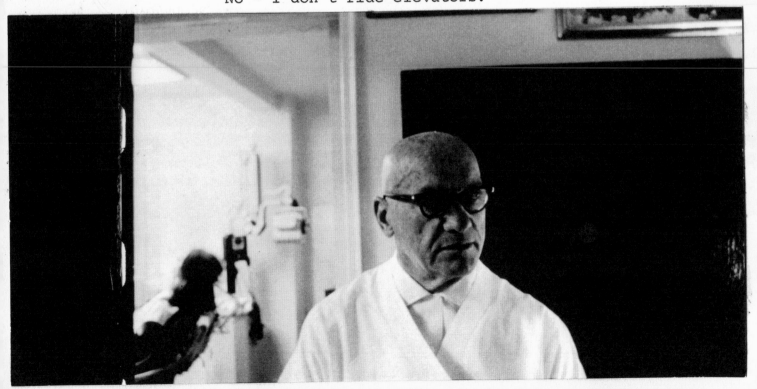

Actress:

Well, it's hard to remember. You have a lot of
people on your mind and you don't remember everything. Is
that true?

You're nervous? You're afraid to go to the dentist.
It doesn't hurt. Well, yes, I mean we have very painful
lives and very painful relationships with people and oh -

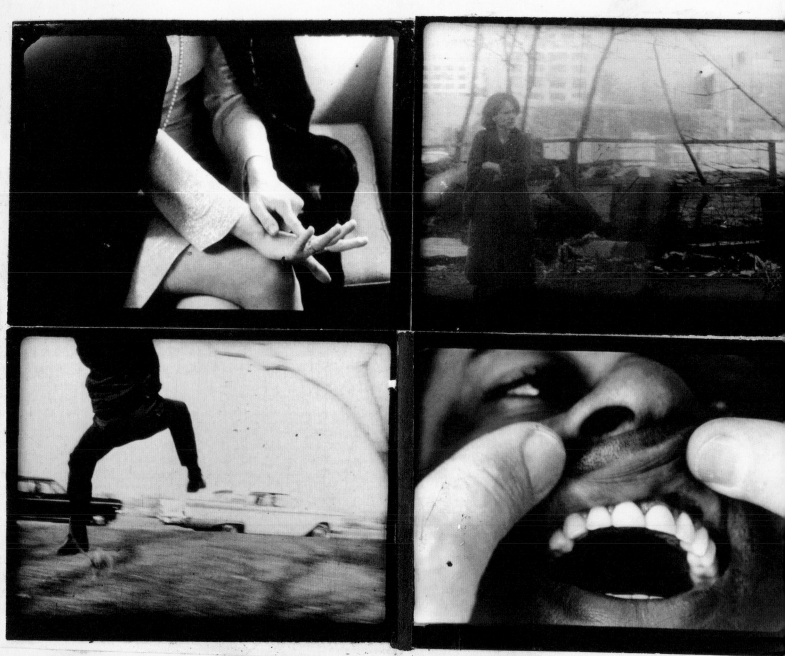

God knows, there's enough pain in the world without having
to have it in your teeth...

Maybe you're rich or something...with a secret life
that you won't tell anyone about - no matter how lonely
they are, or no matter how pretty they are - you just
won't tell. Doesn't matter - I'll guess. I'll tell you
about yourself.

OK, you're a documentary photographer. Or maybe
you're like a reportage photographer. You know - that's a
strange thing, you know, because like some guy is killing
a woman right in front of you - and like - you're taking
a fucking picture of it. You're not helping a woman save
her life - you're getting a story.

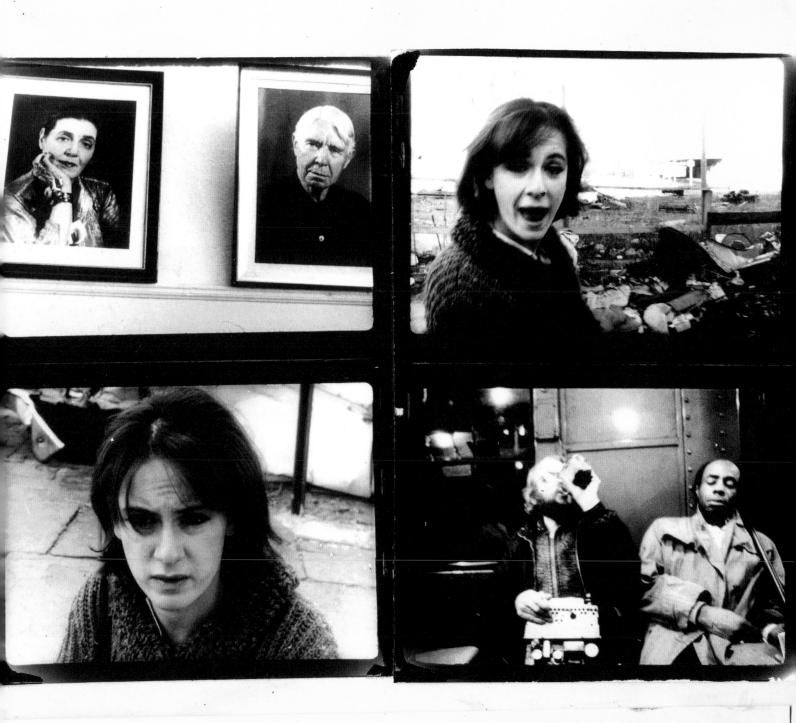

No. Should I tell you what I really do? I'm an
actress. I'm an aging alcoholic actress and - eh - oh -
I'm very proud of that. And - the reason I'm talking to
you is that I'd love to make a movie. I've been out of
work for so terribly terrible long...and you have a
very poetic sensibility.....

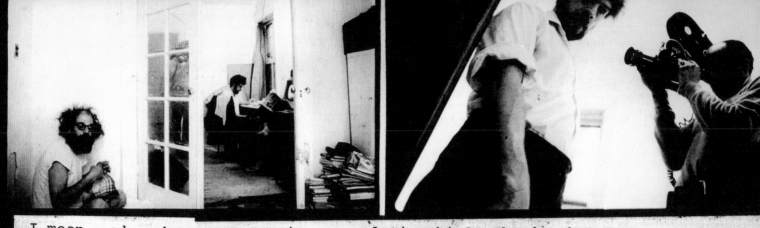

I mean - where's your one to one relationship? That's what I want to know.

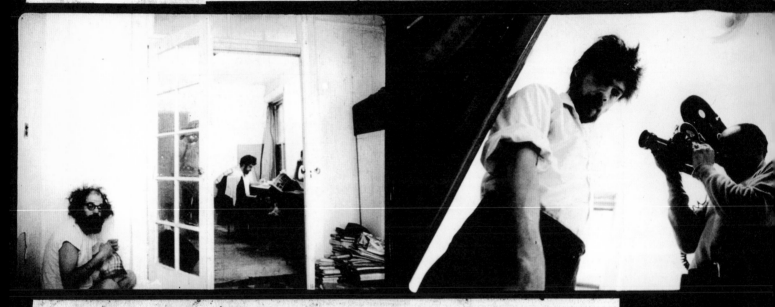

You're a creep. You are some blackmailer. Wow.

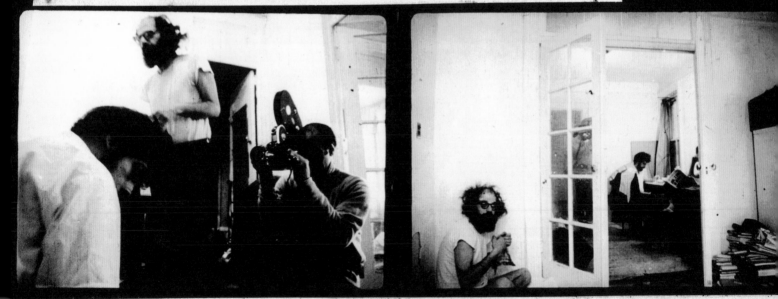

Because you're always watching privacy.

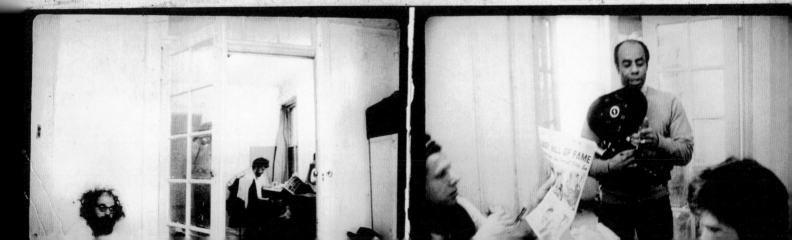

I didn't tell you my name, did I? I have many
names but the name I'd like to give to you today is
Kismet Nagy - Kiss for short...

I'm a day-dreamer. I dream by day and I sleep
by night. I'm anti-Freudian - I'm obsolete - I'm the girl
of tomorrow.

I have to look at one thing at a time. You're a
photographer - you understand this. You make movies.
Can you look at more than one thing at a time, and by
looking at that one thing don't you see everything
ultimately? But if you look at everything, you see nothing.

I see things, and if I could get behind a lens and
see things straight - you know - I could make a fortune.
I mean it's there the fools - there's money, there's money,
don't they know that? You could make a fortune. And
I'm not talking about gold or treasure. I'm talking about
being on the top - you know - making a movie? All right -
make a movie of how it really is.

Don't make a movie about making a movie. Make it.
Forget about the film - throw away the camera - just take
the strip - wouldn't it be fantastic if you didn't have
to have a piece of celluloid between you and what you
saw? If the eye were its own projector instead of its
own camera? I am a camera. That's a beautiful title -
I am a camera too.

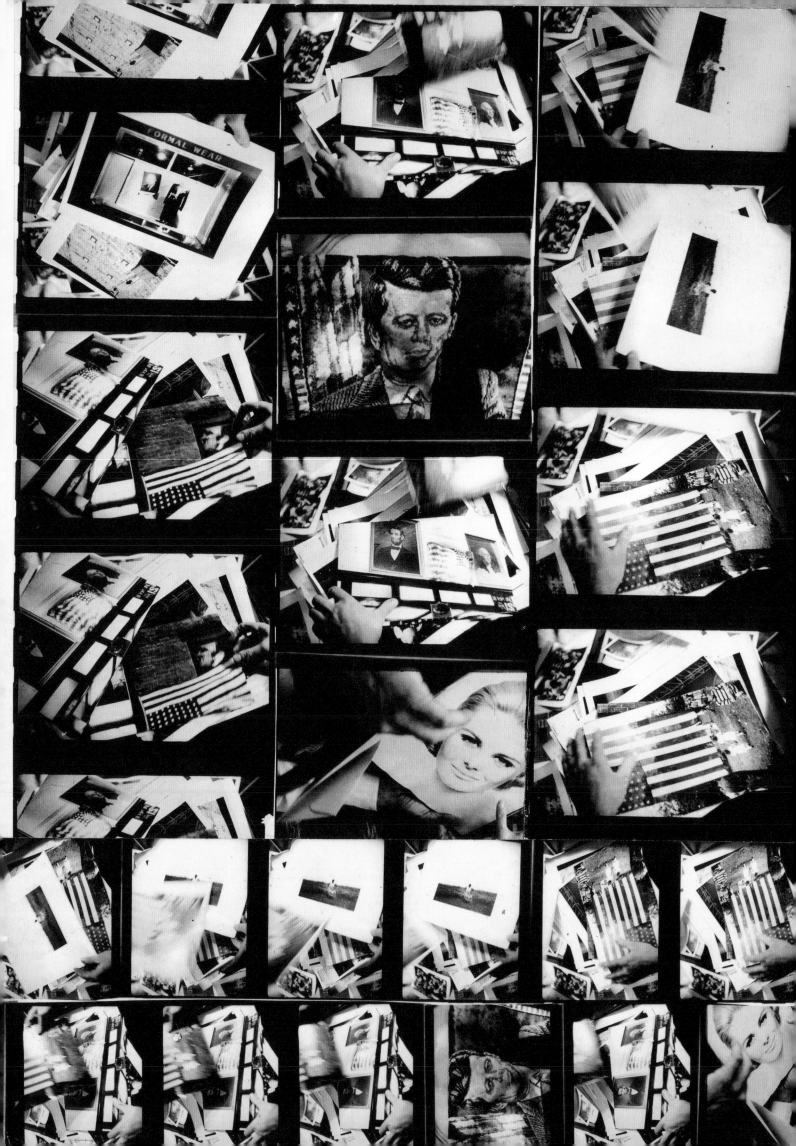

EXCERPT OF SENATOR DIRKSON's SPEECH NOMINATING GOLDWATER

Scene 15

Senator Dirkson:

"...in that spirit, let me tell you simply and briefly about a man - he is the grandson of a peddler. A peddler who was a proud, honorable and spirited man who left his ancestral country in Europe at an early age. And it is about his grandson that I would speak to you this afternoon, and that grandson's name is Barry Goldwater..."

42.

REMAINING TWENTY PAGES OF THE SCRIPT

Social Worker:

Hey - Julius - do you remember me? I'm from the Welfare Department. I'd like to ask you a few questions after you've finished your breakfast. Julius...Julius - come sit here and talk to me for a minute. I want to ask you a question. Would you read these headlines to me, please?

Julius:

25 kids on wild burning bus. Crippled boy killed - 12 hurt.

Social Worker:

You read very well. That was very good. Julius - why did you stop reading? Won't you read to me some more? Let me ask you a question? Do you know who you are?

Child's Voice:

Who are you?

Man's Voice:

 Julius - will you tell me your name?

Child's Voice:

 What is your brother's name? What is your name?

Man's Voice:

 Let me ask you a question. Did you help your
brother paint the room?

Social Worker:

 Did you paint this wall, Julius? Julius - look at
my eyes - they're almost the same color as your"s. Look
at me.

Man's Voice:

 Look at my eyes - they're almost the same color as
your's. Look at me. Look.

Social Worker:

 Do you want to? I want you to. Hey - hey - could
you tell me your name? Let me ask you a question. Would
you talk to me for a minute?

Interviewer:

 Let me ask you a question. What are your impressions
from your last trip?

Second Actress:

 I saw the Matterhorn. I saw costumed women doing
weaving. I saw men carving little animals. I saw the Swiss
Alps, and skiing.

Women"s Voice:

 Why do you take these trips?

Second Actress:

What kind of question is that?

Interviewer:

You have an exceptional ability to express yourself.

How come?

Second Actress:

Yes - well - since - eh - since I'm an actress -
I'm - eh - very sensitive to eh - new trends in literature.
Especially to that group at the New School. I think
that that group really says something definite to me
about the world that we live in.

Voice:

Oh, God.

Second Actress:

Don't you think that it does?

Voice:

Are you trying to put me on?

Second Actress:

Every day is an act.

Interviewer:

All these young queer playwrites. What do you
think of them?

Second Actress:

They should be musqueteers, and protect women instead
of killing them.

Interviewer:

How did you get to where you are now?

Second Actress:

It's hard for me to answer the question. You see,
I'm not a pusher. You know - I'm a lover -

Voice:

What are you talking about? Do you know? Do you
know what the hell you're saying? Who do you think you
are?

Second Actress:

I don't know how to discuss or describe this. It
has to do with your Karma - your Karma's your past lives -
your past deeds, and you're put back here when you do
bad deeds, believe me.

Voice:

Fantastic - she really says those things. Or maybe
she's been kidding from the beginning.

Second Actress:

How did I begin? I began by concentrating on
objects like candles and mandolets, and then eventually
I was not afraid of myself anymore. I began to
concentrate on myself. I began by relaxing all the
externals - I began by inward concentration on all my
organs - which went into my toes, my calves, my thighs,
my buttocks, and, and feel the generation of heat in my
cheeks - around your belly button---

INDIAN MUSIC IN BACKGROUND

---go into your pancreas - relax all the organs - relax the
head, relax your heart, relax - go back into the
state you had when you were a baby - which is complete
consciousness. You have no ideas - no opinions - realize
that you are - the perceiver - you know - like this - and

the perception is always changing - because that's an ocean
of change and lies and illusion...

Voice (overlap):

I know whe believes what she's saying, but to be
screwed up enough to believe it.....I can't find out any-
thing here. I'm going back to my own house. You don't
know what you're talking about. You're a jerk.

Second Actress:

...and eventually go back to the state you had when
you were a baby - which is complete consciousness. You
have no ideas - no opinions - you realize that you are
divine - realize that you are the perceiver - you know -
like this - and the perception is always changing, because
that's an ocean of change and lies and illusion...and you've
been here before - and it's not different - and always was.

Interviewer:

Boy - you really swing. How'd you get your rhythym?

Second Actress:

Rhythym. Rhythym is something natural - you always
have it as a child. When you lose your rhythym...

INDIAN MUSIC ENDS

...it means you're not in your own house. You see. And
when you find the sense of a tune it means that you're
in your center.

Interviewer:

Wow. Crazy. You really come on! You know so much
about everything - literature, philosophy, communism and
capitalism, poetry, poverty and anti-poverty, Zen,

Buddhism and Babtism, and baseball - wow - you're terrific.
I sure dig you! You're too much.

Social Worker:

 Touch me. Touch me please. Look at my eyes, Julius.

They're almost the same color as yours. Julius. Please try
to answer me. I can't stay here very long - I must go on.
I want you to write your name on this piece of paper. It's
a form.....

 Julius....You know what I like most of all? I like
most of all when you smile. You have a beautiful smile....
Will you smile for me? Julius. Please smile for me.

 Don't you like me coming here to help you - to find
out what you need and what you want? Come here. Come
here and touch me.

 Touch Me Please....

 Take my hand. Don't move away from me - don't be
frightened of me. I'm not going to hurt you...Julius -
please - don't look so scared.

 Don't you remember who I am? I'm Virginia. Aren't
you glad to be out of the hospital? Peter tells me that

you don't like to keep your room neat. Now, Peter loves

you but you must keep yourself neat, you must keep yourself

clean........

Peter's Voice off screen:

 That dirty prick....

Social Worker:

 Put your things away...

JULIUS - DAYTIME - CENTRAL PARK
Peter off screen:

 If he don't keep clean I'll take his fucking prick

and throw it in the goddamn laundry wringer - what do they

call those things they put laundry out to dry in - that's

what we'll do with his dick - we'll take a fuckin' laundry-

wringer - and if his ass ain't clean, then we'll take a

goddamn broom and stick it up his ass and make him go ZOOM.

We'll do a lot of fucking things to get him clean in the

morning.

 I got to worry about him all the time - it's not fair -

it's not fair. Come on, goddamn it Julius, you got to

see your brother Peter - it's not fair - got to keep

yourself clean - got to keep yourself clean - got to

keep your room clean like I do. Yeah.

 All these goddamn people around here - but you -

you got to keep yourself clean or you'll go back to the

hospital again and I'll break every fucking bone in your

body. I'll kill you. Oh - you better go back to that

fucking hospital, yes - you do.

Fuck you - may you rot there. That, little beast -
bh - that little beast.

NIGHT TIME CENTER OF PARIS MUSIC OF THE BELLS
FIRECRACKERS

Allen:

So - Peter and I started out, and Julius was coming
along with our friends, and they came to the door. I
was inside already, the place was crowded, and Julius wasn't
there, suddenly. This took place between the car and the
Digger's Place. He disappeared in the rain.

So he got lost again, just like he did in New York.
So we couldn't find him, for like a long long time. We
went to the Police in San Francisco, and went riding along
with them all through the Haight-Ashbury section. But -
no dice - he simply disappeared into the streets of San
Francisco.

Director Off Screen:

Get the hat Peter.

Allen:

It's July Fourth outside, now - that's why there's
all those firecrackers.

Director Off screen:

Hey Peter - start talking.

Peter:'

He was wearing oh - grey-oh-shoes, eh - black pants,
tan shirt, grey raincoat, and he ahd on a Uncle Sam's color

hat - with red and blue and white stripes, and oh - so the
cop is filling out these - eh - forms, and the detective
gets on the phone to call Missing Person's to find out if
they reported anything in, and while he's speaking on the
phone to the Missing Person's bureau, eh - gives my
brother's name, eh - and - oh - gives my brother's name,
gives it like this:

O as in Offense,

R as in Robber,

L as in Illegal,

O as in Operation,

V as in Violence,

S as in Steel,

K as in - eh - Killer,

and Y as in - eh - Why not. Eh - Y as in, eh - Y
as in eh - Y as in, eh - Y - Y - Y what the fuck is Y?

Allen:

But how did we get the hat back if he got lost in
the hat?

Director Off screen:

He got lost in the hat? Well....

Allen:

I'm Julius, now. I'm Julius.

Peter:

In the rain.

Allen:

I'm Julius now. I'm Julius.

In the rain.

ROCK AND ROLL MUSIC. ACTOR IS ON SCREEN. DIRECTOR AND JULIUS
BOTH OFF SCREEN.

Director (off screen):

But how do you feel about silence?

Julius (off screen):

I don't know - it's not good to be too holy, you
know. It's bad. I mean, it's bad to overdo something.
People tend to overdo things.

Director (off screen):

Like what?

Julius (off screen):

Investigate too much, or be too indifferent, or work
too much. We give off poisons, you know, and we're not
able to see.

Director (off screen):

Do you listen to the words?

Julius (off screen):

Yes.

Director (off screen):

Have you ever loved anybody?

Julius (off screen):

Not really. I"m not able to - there are so many
people in the world. You have to dream up people--

Director (off screen):

Dream up people? That you could love?

Julius (off screen):

Well, either love or hate. I use that to offset any-
thing - to keep on God. You got to keep on God - you
know - sometimes - and sometimes you lose God. You get
lost, and you die - you die away. Fade away - you die
away. It's tragic in a way. But then again other times
it isn't. It's too scary, it's too, too - either too stern
or too rugged.

The only way we have for salvation in the world is
to console one another - console in one another - if
we do that.

But it's not always good to trust, you know - that's
why you have insurance companies, that's why you have banks,
that's why you have robberies, that's why you have murderers,
that's why you have thieves, that's why you have gyppers,
that's why you have law-breakers, muggers,....

BEGINNING OF CAR SEQUENCE

...thieves, killers of every kind.....

Leader of boys:

What's your name? You need a shave, man.

Actor:

I had a dream - I was punching somebody, I was
hitting him in the face, I was actually hitting him. I
used to - I used to hit myself.

I would stick cigarettes in my skin. I used to bang
myself, I used to swing at other guys, I used to swing at

stone walls - oh - I - I - that's because people used to throw rocks at me...that's why I set fire to a house.

I didn't have many friends but I remember George. Do you know George? We used to work together out in Long Island.

That's when I had a cat - my old cat - Thomachevsky - he was a sad one and an unnoticed one. Too neutral...

Suffering, that's what it is. Beggers of their days. I'm trying to get away - trying to save my own ass...I have to make further adjustments - I look forward to going back to the bughouse. I want to settle down - become a settler. there's no formula for everybody - you have to find your own.

You've got to theorize - you've got to free - landscape - you've got to glance at things freely. In a sense it's horrible. Things are never perfect. I have an impatience that I can't qualify - can't meet the standards. I can't help laughing, though.

Maybe I'm just - maybe I'm just acting, acting it out. Time is passing me by. Got too much time on my hands. The time element causes people to get lost. That's another tragedy. So maybe there's more than one tragedy in the world.

I feel sad about growing up. Not much to do. Just to dream - dream up things. I had a dream - I dreamed I was kissing a baby...

END OF SCENE WITH BOYS AT CAR

BATHROOM

Actor:

Why did I get shocks? Electric shocks? I've gotten shocks through sockets. I've gotten shock through sockets - I oh - remember that. Where have they gone - the shock? Will they come back? Sure - sure they will. I - I can't describe electric shock. I can't remember - it was so - so - so quiet.

I'm not able to love anybody because there are too many people in the world - too many people - to love or to hate.

I get jealous of babies because I think it's sad to grow up and people ought to put their time to use. Eh - Christ gave up hope altogether. Nobody helps anybody else, so one tends to deny the charges. Like Bob Dylan says, "It ain't me, babe."

What's next?

My speech is all used up - I have nothing else to say - nothing else to read from - I don't know who to play.

Photographer:

Say something to the camera.

Actor:

So what should I do now - who should I be? Who should I play?

Photographer:

Wait a minute, Joe - Hey, Joe, do you remember a

letter you once wrote? Let me read you some of those
words - it's really a marvelous letter, Joe.

Actor:

 I have to go now - I can't wait.

Photographer:

 "Sometimes I go off somewhere, and I start to walk
like Julius, as though walking like him I'm where he is.

 "I can't figure out why where he's at seems like a
better place to be. Maybe I'm being romantic, but where
he is seems like a meeting place, a common denominator.

 "If you strip anybody of his style, he'd be where
Julius is."

Allen:

 "...patient was admitted to this hospital on
February 27th - San Francisco General - a note on the chart
made by the admitting physician states that the commit-
ment papers state that the patient is 32 years old and that
his name is George Orlovsky. The patient will not talk -
refuses to answer questions.

 "At the present time, when asked his name he says his
name is George Joseph. When asked his age he whispered
that he was 25. After these two questions, the patient
refused to answer any questions whatsoever."

Gregory:

 So how old is he?

Peter:

 Thirty-three.

Allen:

"...He responds to orders so far as moving about, getting up, sitting down, taking off his jacket. However he refuses to answer any questions. He did nod his head when asked if he had ever been in this hospital before.

"He has been quiet and cooperative on the ward and has never, according to the nurses' notes, returned a spoken answer to a question.

"Physical examination reveals a healthy young white male.

"Exam was essentially negative except for a healing either surgical or knife incision in the lower abdomen. Wound is approximately eight inches long and somewhat resembles a Pffannensteil scar. Patient refuses to say whether it was an injury or surgery or what was done or when it was done.

"Patient weighs 142 pounds, is 5 foot 8.

"Diagnosis - schitzophrenic reaction - catatonic type."

Peter:

He's peaceful, that's all - he's peaceful.

Allen:

"Recommendation for treatment and further study-- ward therapy, pheno-thiazide therapy, and as his further outlook improves."

Gregory:

Is that the letter from the head doctor, or what?

Allen:

Signed by Robert Kuhmer. MDGM.

Gregory:

What does that mean?

Allen:

MD means medical doctor and GM is his secretary.

Director (off screen):

We arrive at Napa State - we drive through the gate.

Peter:

Napa State, Napa State - ninety million miles away, ninety miles away.

Director (off screen):

It was raining...

Peter:

Dr. Eichman. What was his first name again?

Director (off screen):

I forgot. Now - what was the idea that you picked up the broom and started to pick up every little speck of dirt?

Peter:

Well, the idea was - the - to - that - to have - well, I realized that I was going to have a little wait there - I realized it was going to be a little bit of a wait before we got Julius out of the hospital. So - how much time did I have on my hands...

Director (off screen):

You realized that? You - just to pass the time, you ran around with the broom and started to sweep up the toilet? You must be out of your mind!

Peter:

I must be out of my mind, but I got to meet the patients, though.

Director (off screen):

Let's go on from there - the story with the clothes - the clothes you had - and what did you do?

Peter:

I don't know. Am I supposed to go that far back and remember?

Director (off screen):

Yeah. That's what I want you to do.

Now just once more describe the clothes you brought for him to wear.

Peter:

The clothes I brought for him to wear. Yeah. What clothes? What about it? Oh yes, I said - I said to the hospital - take off those clothes,we don't want those clothes- so take off those clothes and put these clothes on - we don't want anything from this hospital. Right? All right.

Director (off screen):

When was it he changed and what did he have on?

Peter:

Better clothes than the ones I was giving him.

Director (off screen):

Did Julius say anything when you took the clothes away - when you returned the clothes to the hospital?

Peter:

Yeah - I don't think he wanted to give them back.

I think he wanted their clothes.

Director (off screen):

What was the next thing you did? You remember?

Peter:

I asked him how many shock treatments he got and what was the voltage.

Director (off screen):

All right - now how about his talking?

Peter:

What about his talking? Wait - I want to get some oil from the bathroom and put it on my hands. Now - what were you saying?

Director (off screen):

The fact that he stood there and said, "Hello, Robert - have you come all the way from New York?" I remember that he said that.

Peter:

Yes, You came all the way from New York.

Director (off screen):

Now what did you think that all of a sudden he was talking clearly?

Peter:

Well, I thought it was about fucking time - I'd give him a boot in the ass if he wasn't talking - I want to hear an account of where - I took him out of the hospital - he'd been there 13 years.

I don't know why the fuck I took him out of the hospital - I shouldn't even have bothered with him any more - I'm

tired of running after him. He's supposed to take care
of himself from now on.

Goddamn it. He's nothing but a goddamn leach- he's
worse than a leach, goddamn it - he's a fucking creep.

Director (off screen):

Now, Julius, we want to know how you feel about
shock treatment? Speak up.

Julius:

I thought maybe I committed a crime - against the
state - by taking shock treatments that weren't at all
justifiable.

Director (off screen):

How?

Julius:

Well - considering any experiential outcome of - of
being in shock treatment or around it or near it or talking
about shock treatment.

Director (off screen):

What do you think of Allen?

Julius:

Allen? I consider Allen as - as just being Allen.
For what he is. I'm not too - too - too familiar with
the man any more than I am actually. That's as clear as
I can be on that matter.

Director (off screen):

And Peter?

Julius:

Peter - well - Peter's my brother, and he knows about my receiving shock treatment. For what reason I do not know. Nobody has ever - er - satisfied me eh - eh - oh....

Director (off screen):

Now, how do you feel about acting?

Julius:

Acting is something beyond my collaboration.

Director (off screen):

Tell it to the camera - what do you think about acting?

Julius:

Acting is beyond - my - thought processes sometimes. At times. It may be a waste of time.

Director (off screen):

Stay a little bit more over here, Julius. Yeah - that's good. Say something to the camera.

Julius:

Well, the camera seems like a - a - a reflection of disapproval or disgust or - disappointment or unhelpfulness - ness - or eh - unexplain - unexplainability - unexpainabil- ability - to eh - disclose any real, real truth that might possibly exist.

Director (off screen):

Where does truth exist?

Julius:

Inside and outside - the world. Outside the world - is - well - I don't know. Maybe it's just a theory - an

idea or theory - that is all we can arrive at - a theory

or an explanation - to the matter - whatever you concern

yourself with.

Director (off screen):

Look into the camera. And say"my name is Peter"-

you know -

Julius:

My name is Peter.

Director (off screen):

No - no, your name.

Julius:

My name is Julius Orlovsky.

Director (off screen):

And where do you live?

Julius:

408 East 10th Street.

Director (off screen):

You going back to New York?

Julius:

Eh - yeah - I think on the 17th or something like that -

Peter said - he'd take me out to the island to see my family

there.

Director (off screen):

It's cold, huh?

Julius:

It's chilly, chilly. Well, whether it's cold or not,

I don't know....but....

Director (off screen):

Cut!

ME AND MY BROTHER, USA 1965 – 1968

Director: Robert Frank

Screenplay: Robert Frank, Sam Shepard, Allen Ginsberg, Peter Orlovsky

Camera: Robert Frank

Editors: Robert Frank, Helen Silverstein, Bob Easton, Lynn Ratener

Actors: Julius Orlovsky (Julius Orlovsky), Joseph Chaiken (Julius Orlovsky), John Coe (psychiatrist), Allen Ginsberg (Allen Ginsberg), Peter Orlovsky (Peter Orlovsky), Virginia Kiser (social worker), Nancy Fish (Nancy Fish), Cynthia McAdams (actress), Roscoe Lee Browne (photographer), Christopher Walken (director, voice: Robert Frank), Seth Allen, Maria Tucci, Jack Greenbaum, Beth Porter, Fred Ainsworth, Richard Orzel, Phillipe La Prelle, Otis Young, Gregory Corso, Sally Boar, Joel Press, Louis Waldon

Production company/Producer: Two Faces Company/Helen Silverstein

Length: 91 min.

Format: 35mm, b/w and color

DVD – Mastertape: supervised by Laura Israel

First Edition 2007

Copyright © 2007 Robert Frank for the photos and texts
Copyright © 2007 for this edition Steidl Publishers, Germany

Book design: Robert Frank, Gerhard Steidl
Scans done at Steidl's digital darkroom
Printing: Steidl, Göttingen

Steidl
Düstere Straße 4 / D-37073 Göttingen
Phone +49 551-49 60 60 / Fax +49 551-49 60 649
E-mail: mail@steidl.de / www.steidl.de / www.steidlville.com

ISBN: 978-3-86521-363-1
Printed in Germany